Hagersville Ontario in Photos, Saving Our History One Photo at a Time

Photography
by Barbara Raué
2013

Series Name:
Cruising Ontario

Book 35: Hagersville

Cover photo: The Old Lawson House Eatery and Pub

Series Name: Cruising Ontario

Book 1: London
Book 2: Dundas
Book 3: Hamilton
Book 4: Oakville
Book 5: Chesley
Book 6: Stoney Creek
Book 7: Waterdown
Book 8: Owen Sound
Book 9: Mount Forest
Book 10: Dundalk
Book 11: Burford
Book 12: Waterford
Book 13: Drumbo
Book 14: Sheffield
Book 15: Tavistock
Book 16: Ancaster and Mount Hope
Book 17: Innerkip
Book 18: Brantford
Book 19: Burlington
Book 20: Guelph
Book 21: Ayr
Book 22: Erin
Book 23: Goderich
Book 24: Lucknow
Book 25: Paris
Book 26: Toronto
Book 27: Beaver Valley
Book 28: Collingwood
Book 29: Peterborough

Book 30: Orangeville Beginnings Part 1
Book 31: Orangeville Part 2 and Area
Book 32: Port Elgin
Book 33: Southampton
Book 34: Jarvis
Book 35: Hagersville

Other Books by Barbara Raue

Coins of Gold

Arrows, Indians and Love

The Life and Times of Barbara
Volume 1: Inventions That Have Enhanced My Life
Volume 2: Entertainment That I Have Enjoyed
Volume 3: East Coast Trips
Volume 4: Olympics Have Always Intrigued Me
Volume 5: Wonders of the World
Volume 6: Caribbean Cruises We Have Enjoyed
Volume 7: Animals
Volume 8: Storms and Other Major Disasters in My Lifetime
Volume 9: Wars, Terrorist Attacks and Major Disasters

The Cromwell Family Book

Visit Barbara's website to view all of her books
http://barbararaue.ericraue.com

Hagersville

Hagersville, a community in Haldimand County, is located about 45 kilometres southwest of Hamilton, Ontario, and 15 kilometres southwest of Caledonia.

In 1852, Charles Hager built a frame hotel at the corner of the Plank Road and Indian Line. It was called The Junction Hotel and later The Lawson Hotel after a change in ownership. Hagersville's first post office was in this hotel. With the construction of the Plank Road, a small village popped up in 1855 when Charles and David Hager bought most of the land in the center of the area. David Almas owned the land on the east side of the road, while John Porter owned the land in the west end. Joseph Seymour suggested the community be called Hagersville to honour the Hager brothers.

The building of the Canada Southern Railroad in 1870, and of the Hamilton and Lake Erie Railway three years later helped to make Hagersville a prosperous village.

Hagersville gained notoriety in 1990 with a huge uncontrolled tire fire which spewed toxic smoke into the atmosphere for seventeen days. The fire actually occurred in Townsend, a neighbouring community, but media labeled it as Hagersville due to Townsend's relatively unknown status in the area.

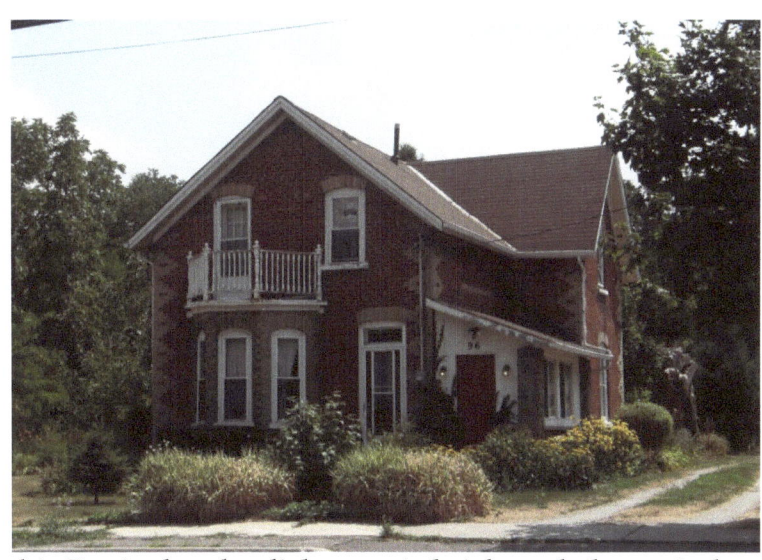

Gothic Revival style, dichromatic brickwork, bay window on ground floor with balcony above

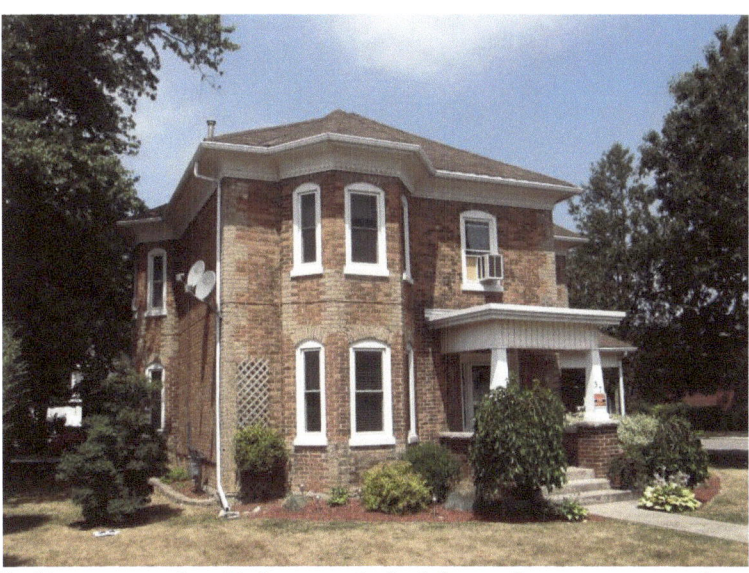

Italianate style, dichromatic brickwork, two-storey bay window

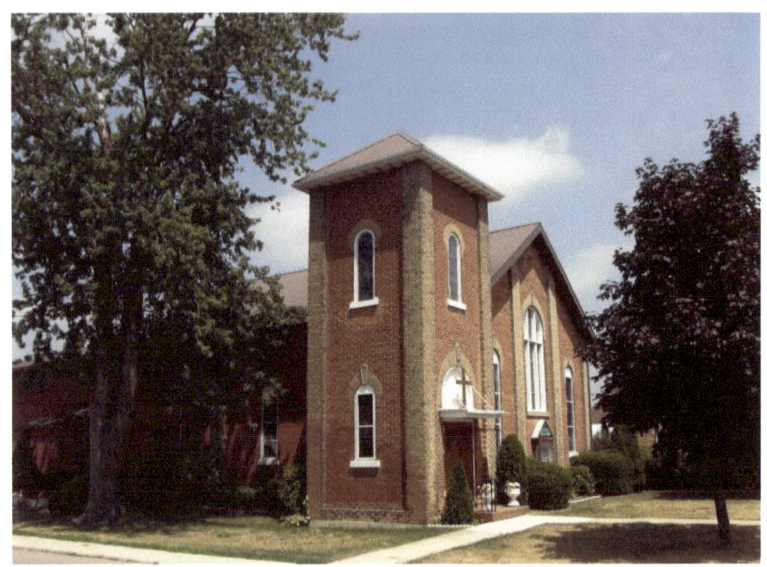

Hagersville Baptist Church, 59 Main Street North

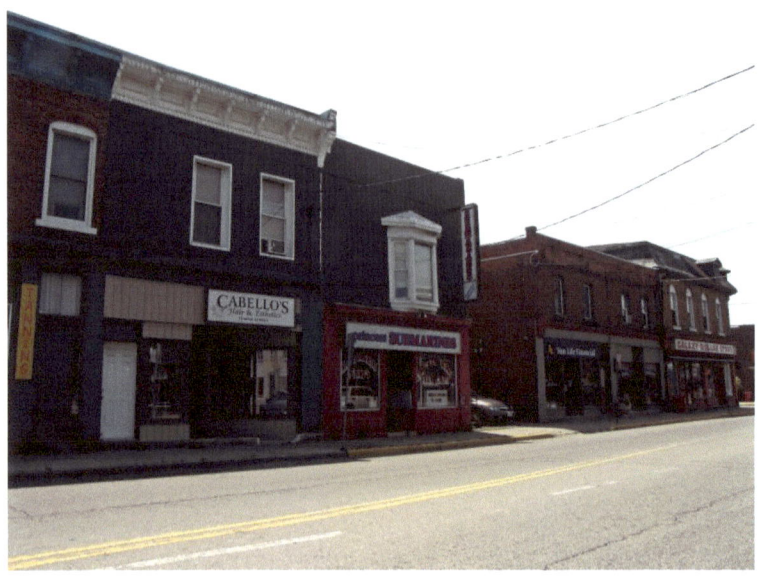

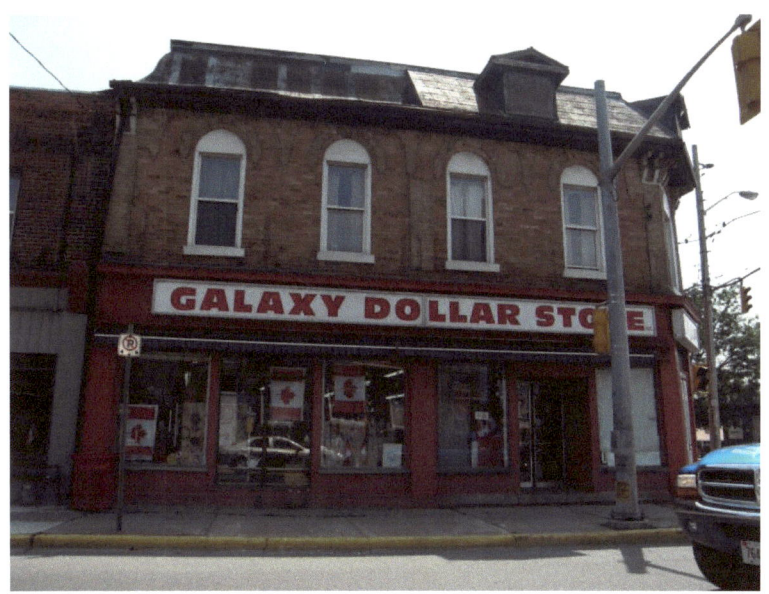

Mansard roof

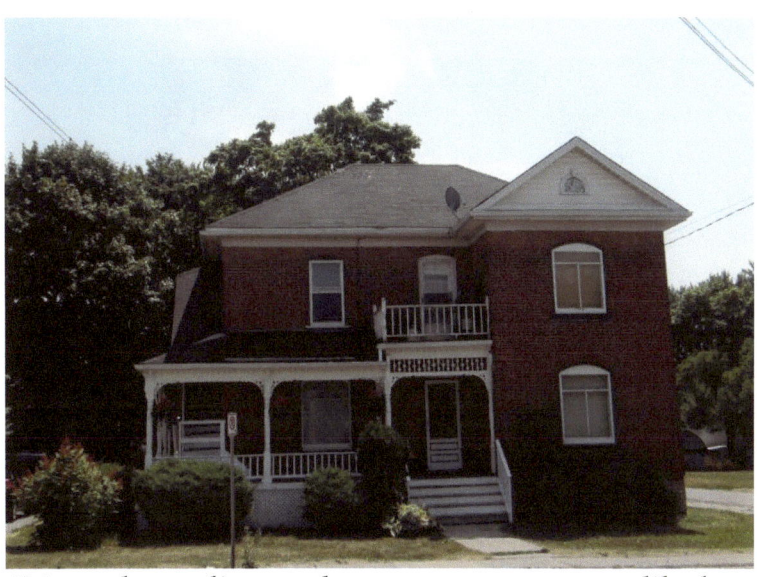

Triangular pediment above two-storey tower like bay

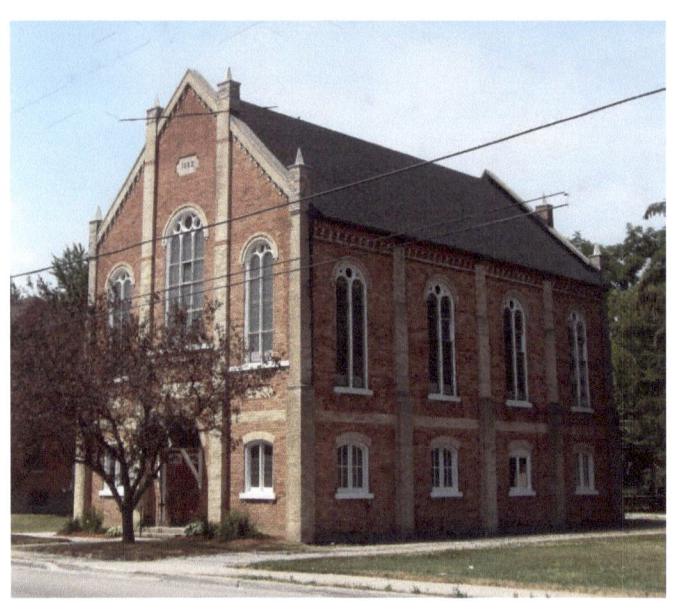

44 Main Street South
St. Andrew's Presbyterian Church - dichromatic brickwork, dentil moulding, buttresses - built in 1883

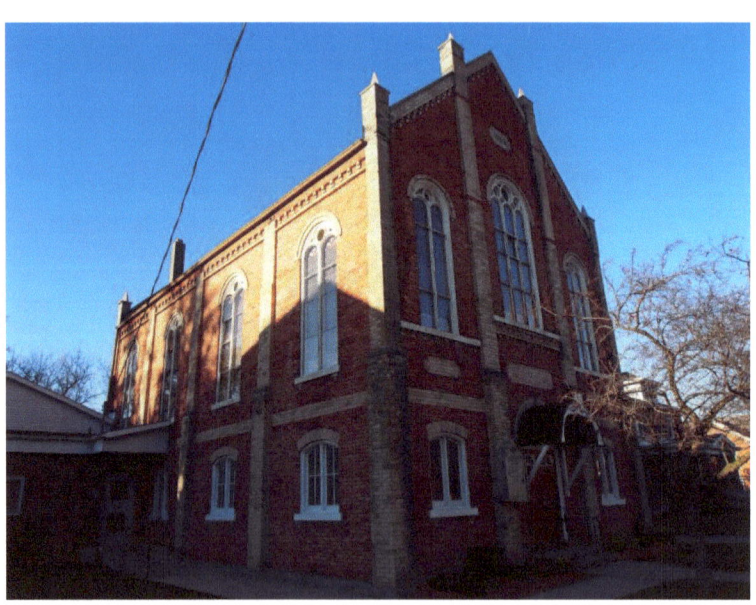

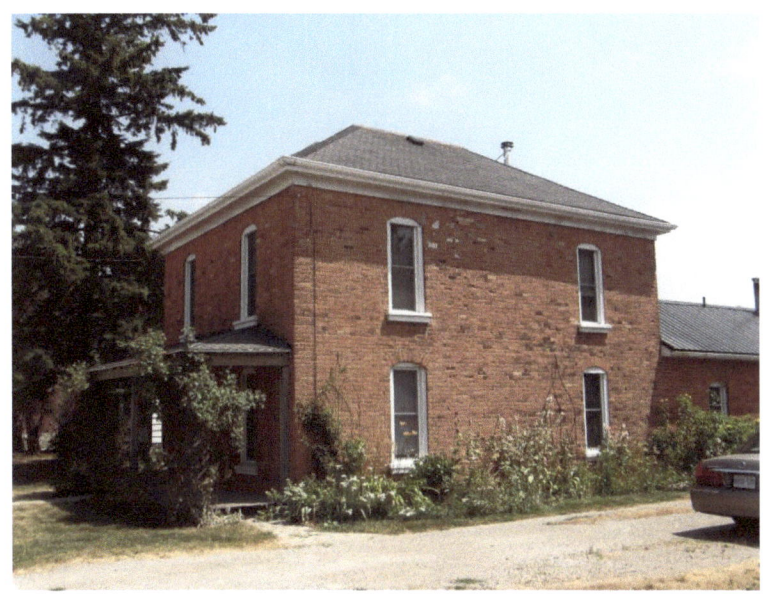

Italianate style with hipped roof

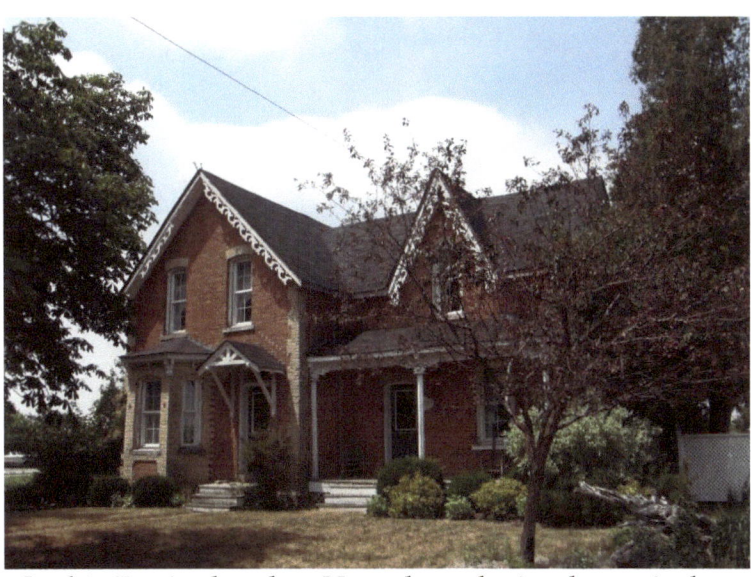

Gothic Revival style – Vergeboard trim, bay window

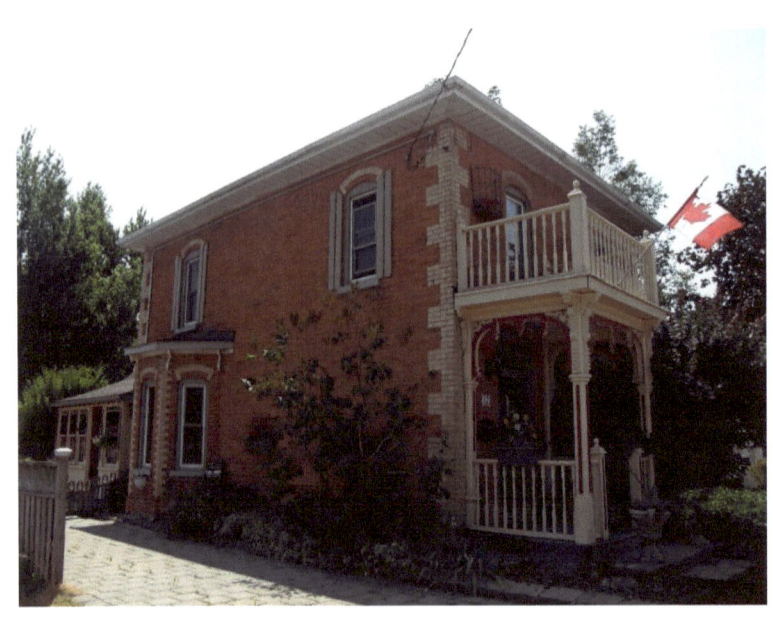

Italianate style - corner quoins, arched window voussoirs

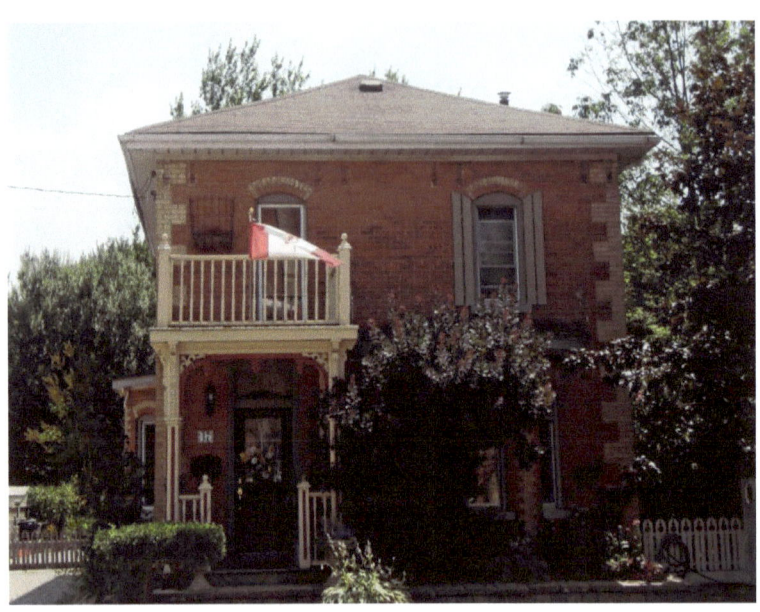

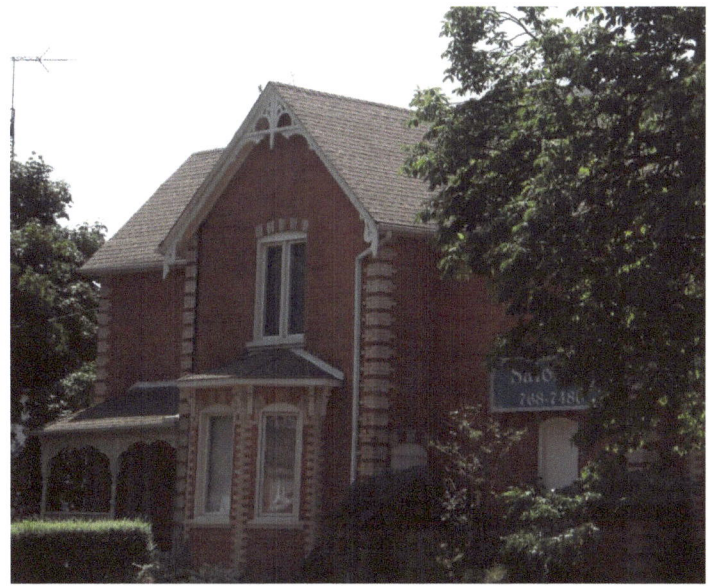

Alma Street South - Gothic Revival style, Vergeboard trim on gables, cornice brackets on bay window, dichromatic brickwork

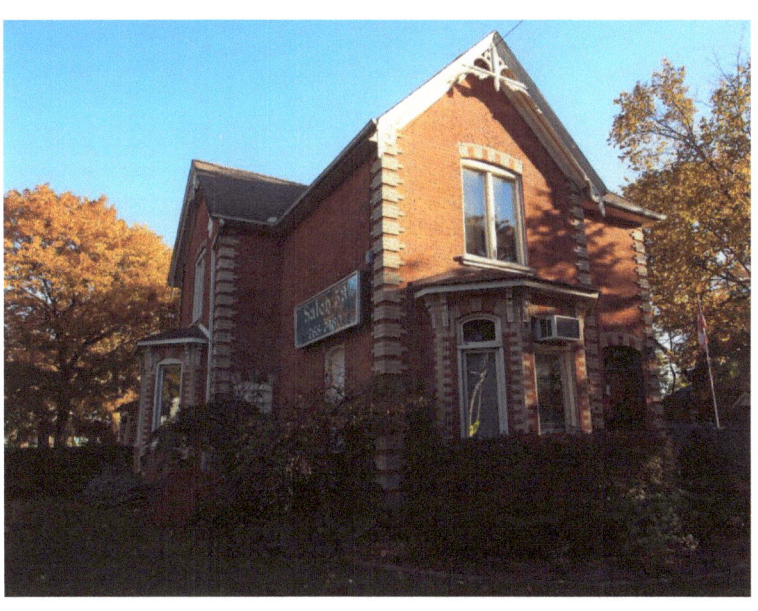

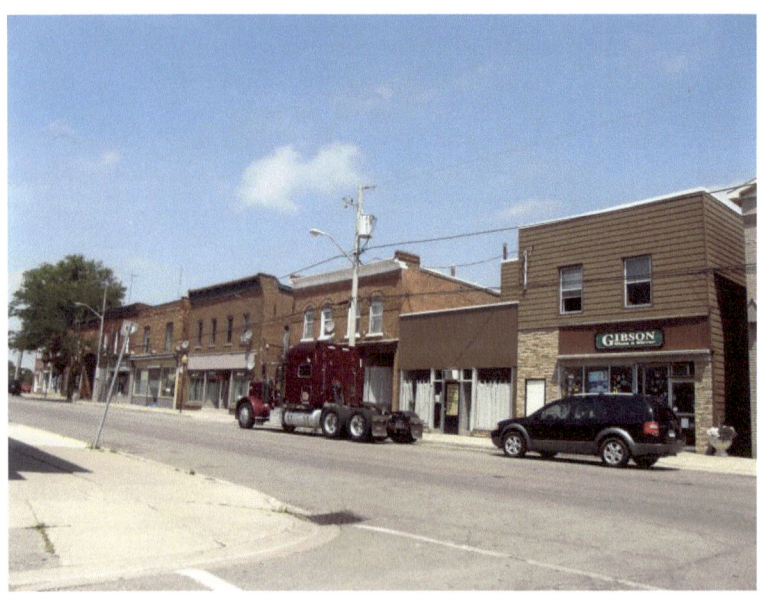

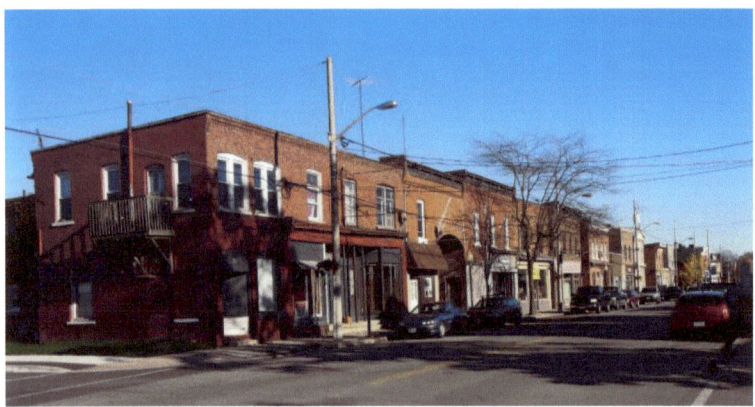

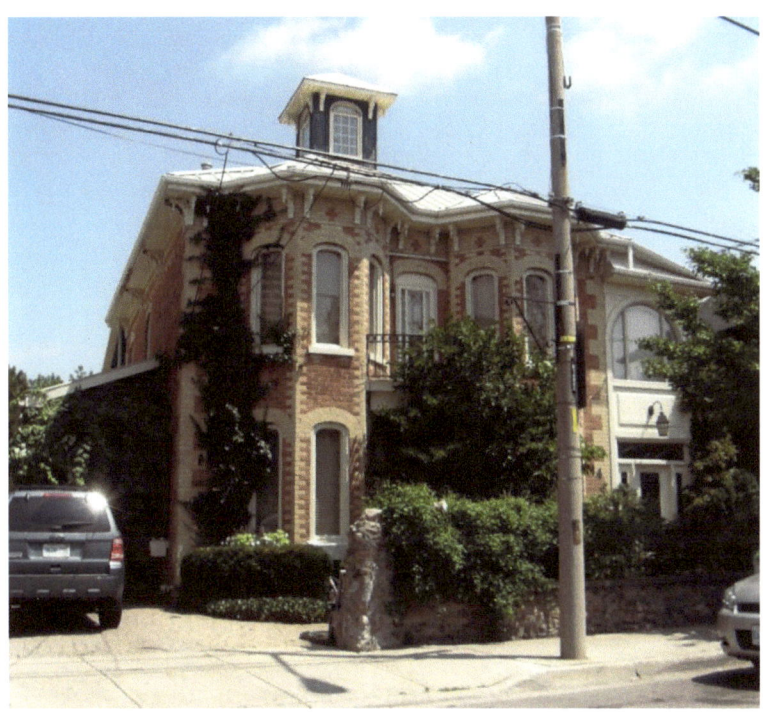

Italianate style, belvedere on rooftop, dichromatic brickwork, cornice brackets

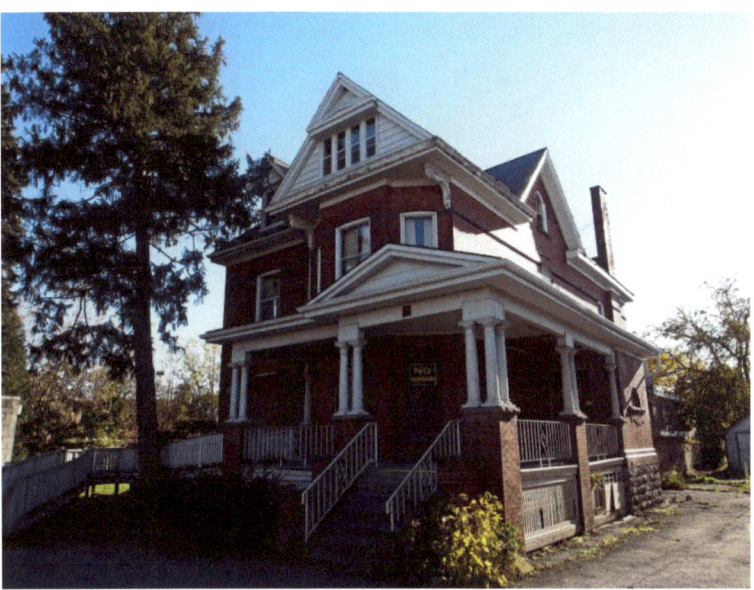

Edwardian/Gothic/Italianate mixture of features

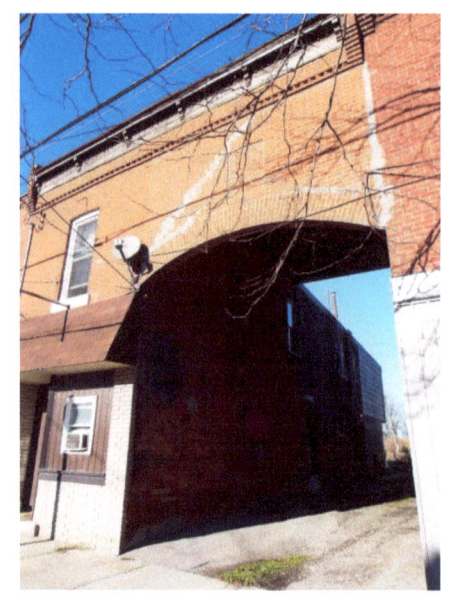

Gateway for carriages to go through

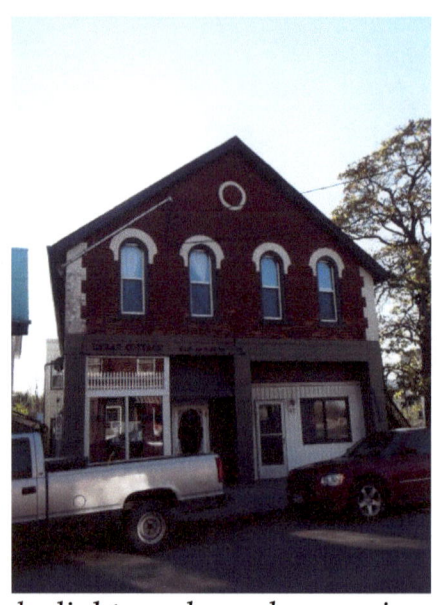

Gothic Revival – lighter coloured voussoirs, corner quoins

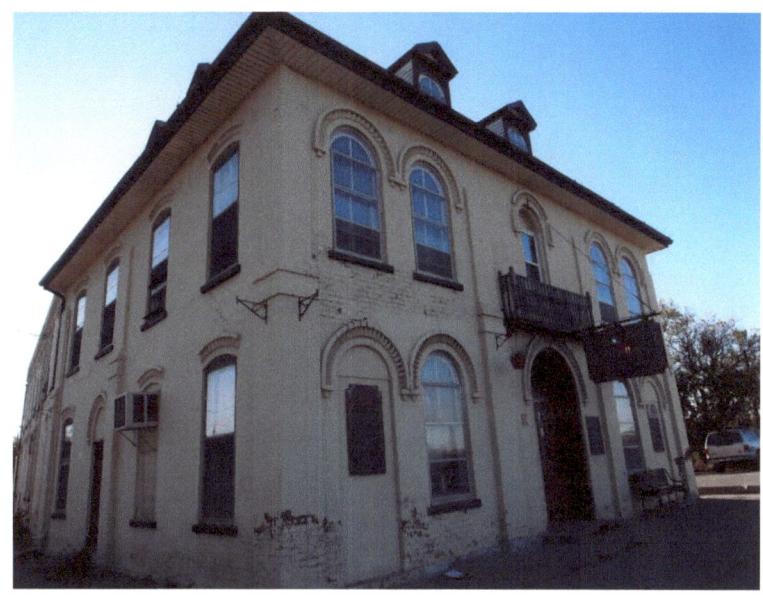

The Old Lawson House Eatery and Pub – dormers, Italianate style, arched window voussoirs

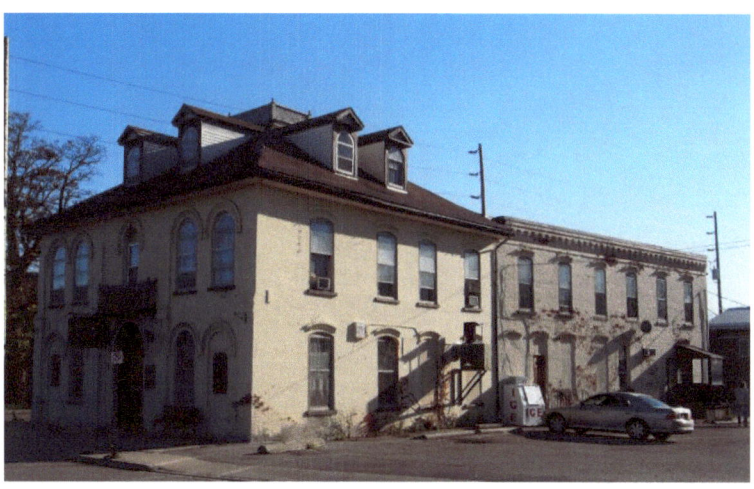

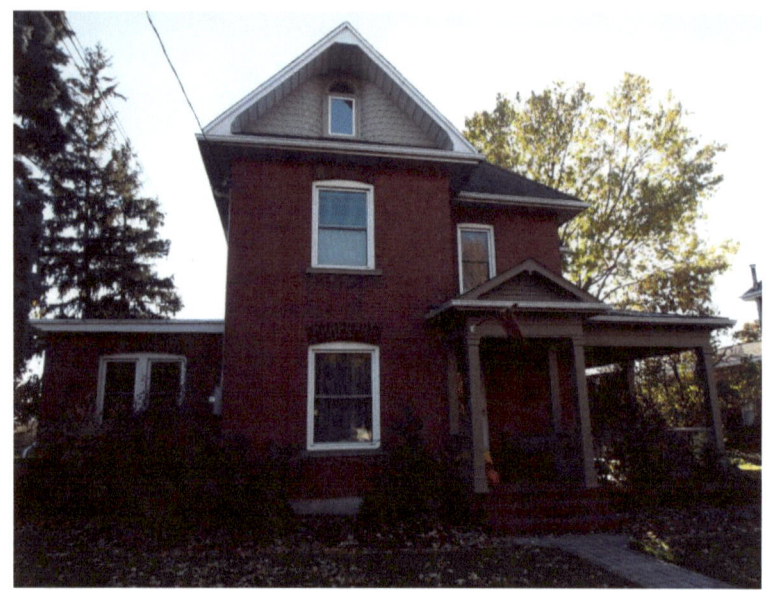

#66
Edwardian/Italianate style

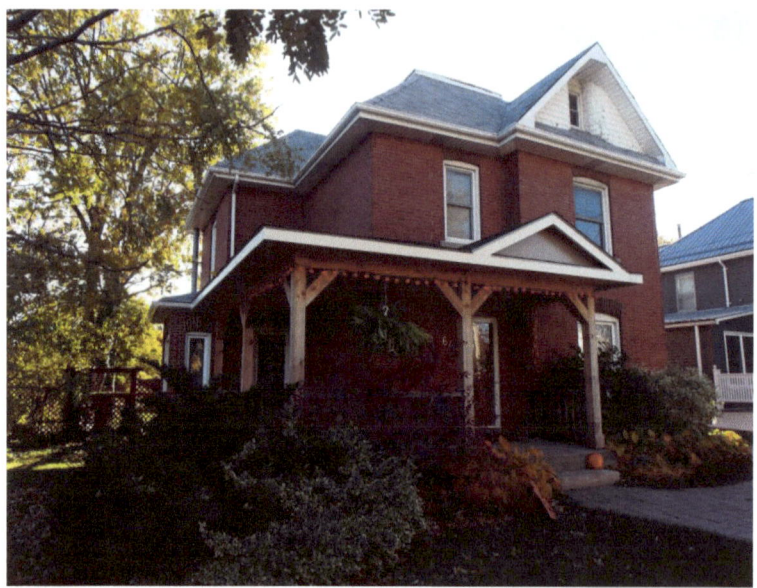

#64

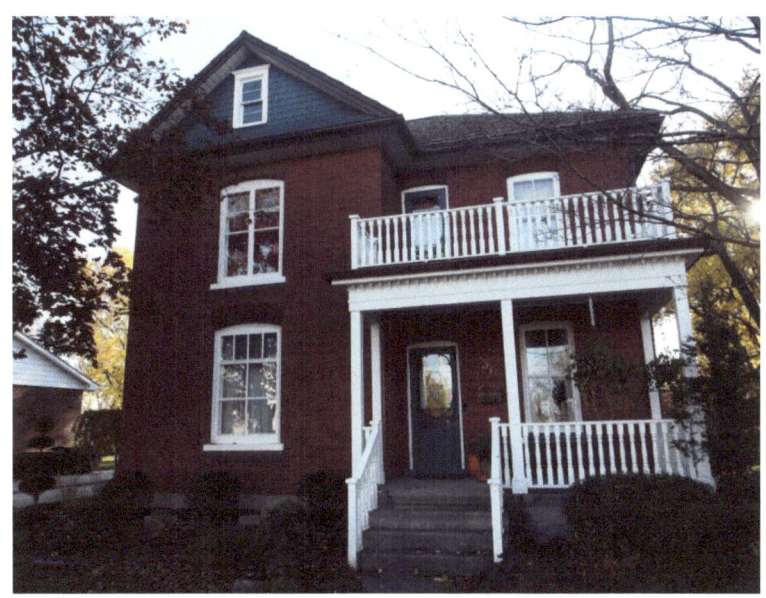

56 King Street East

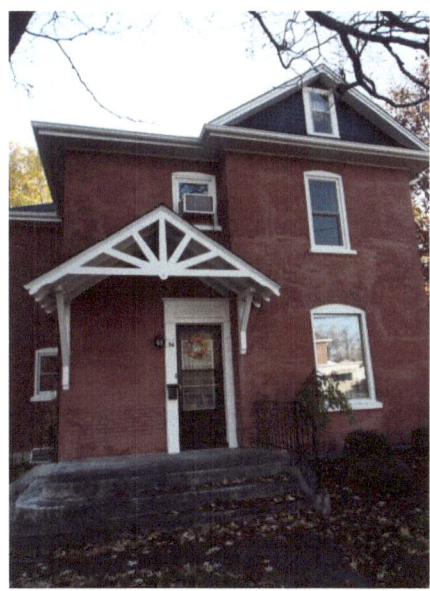

54 King Street East

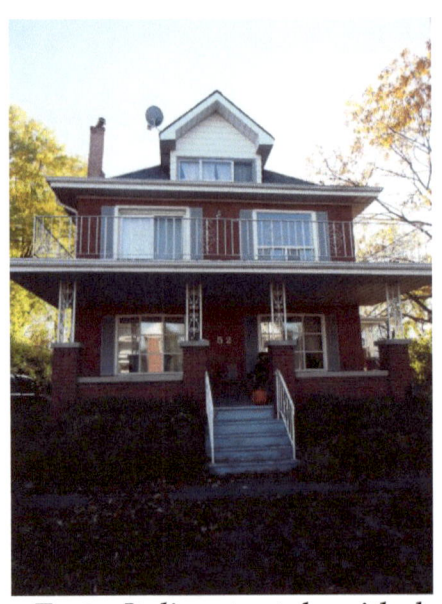

52 King Street East – Italianate style with dormer in attic

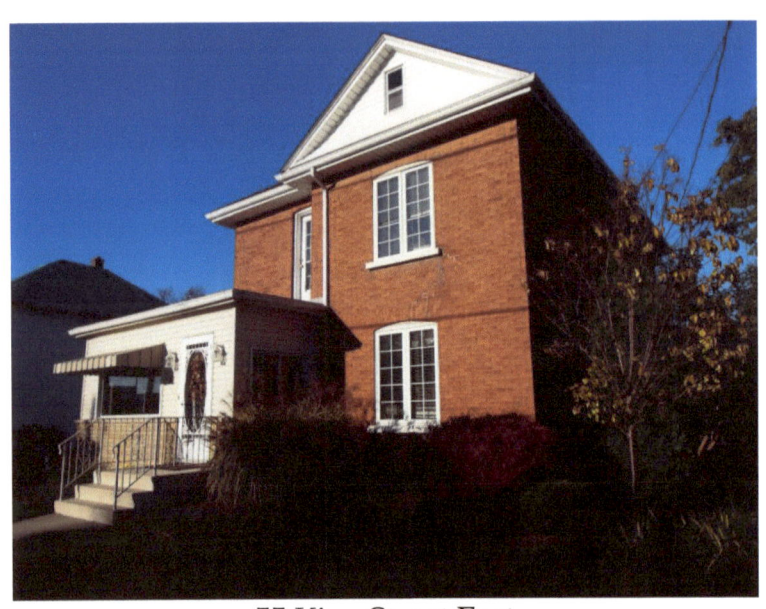

55 King Street East

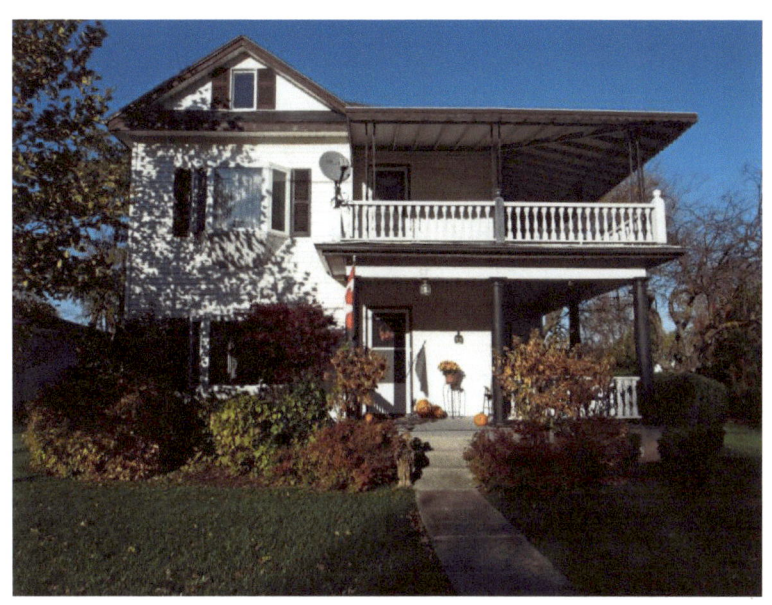

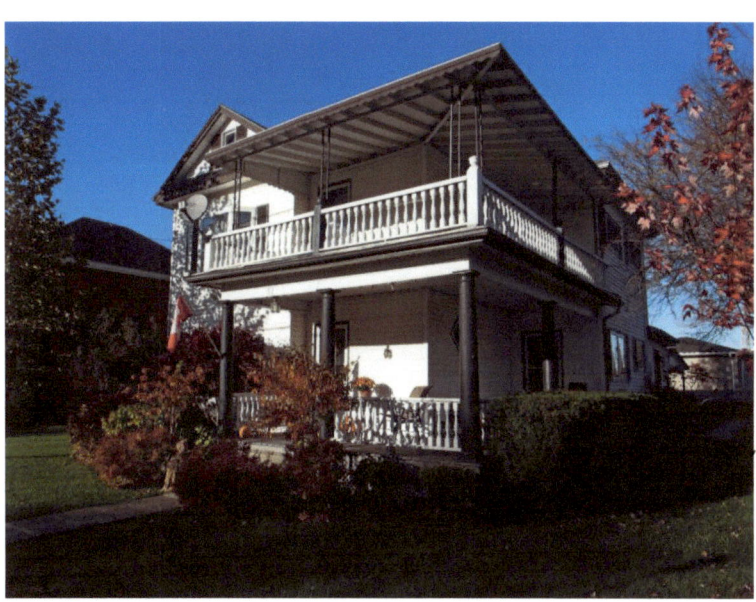

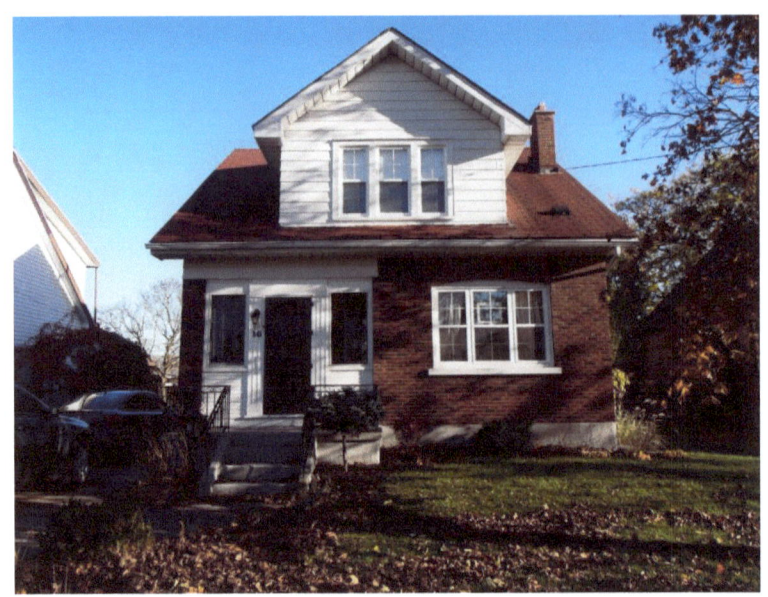

16 King Street East

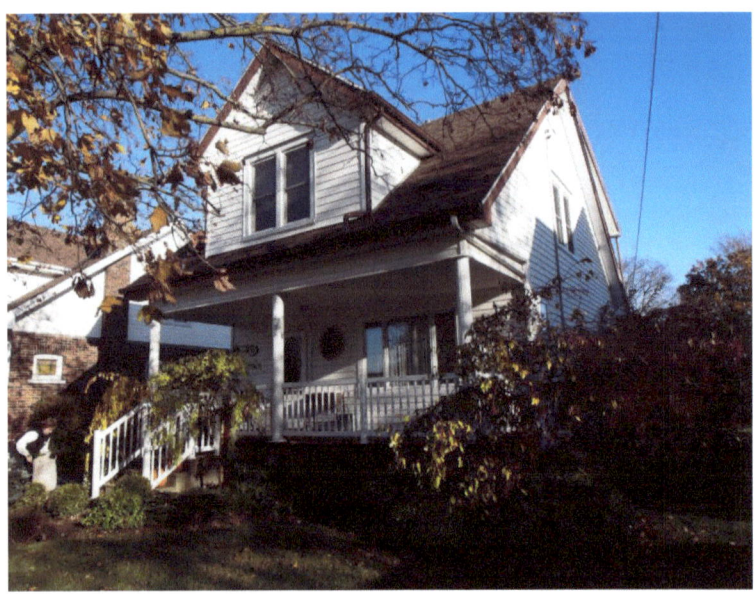

18 King Street East – Gothic Revival, dormer in attic

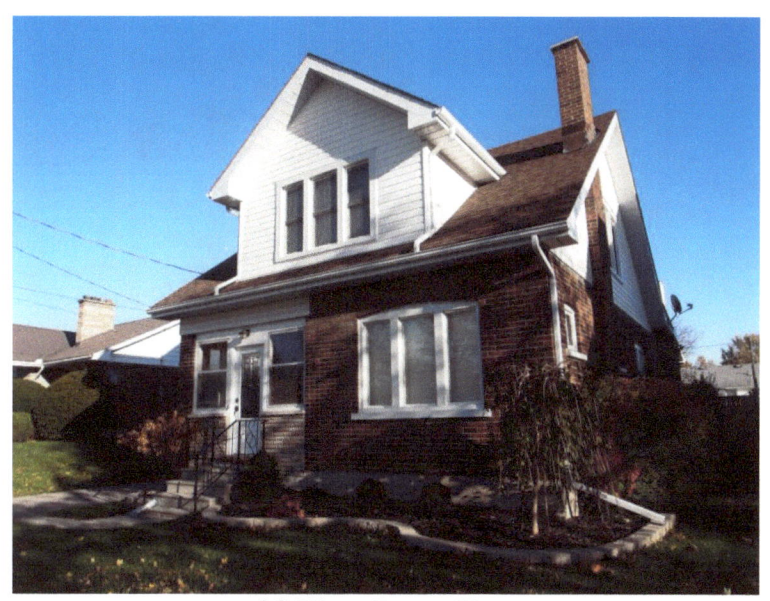

20 King Street East

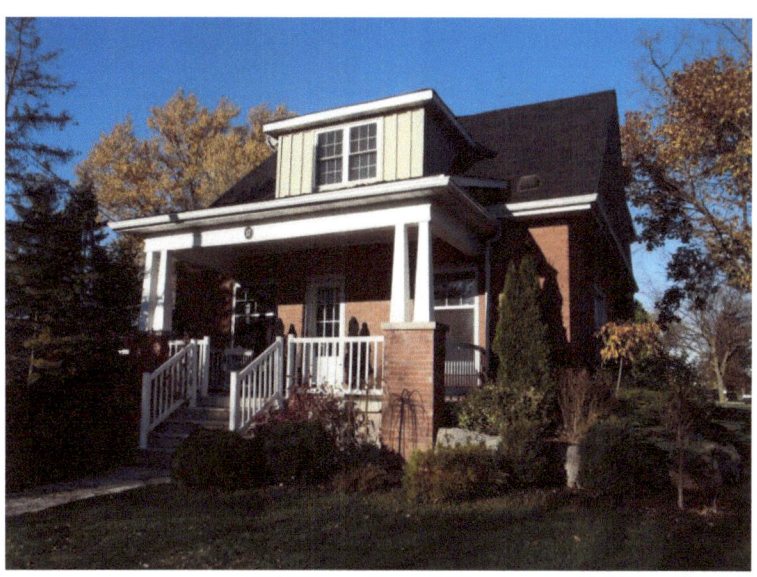

17 King Street East

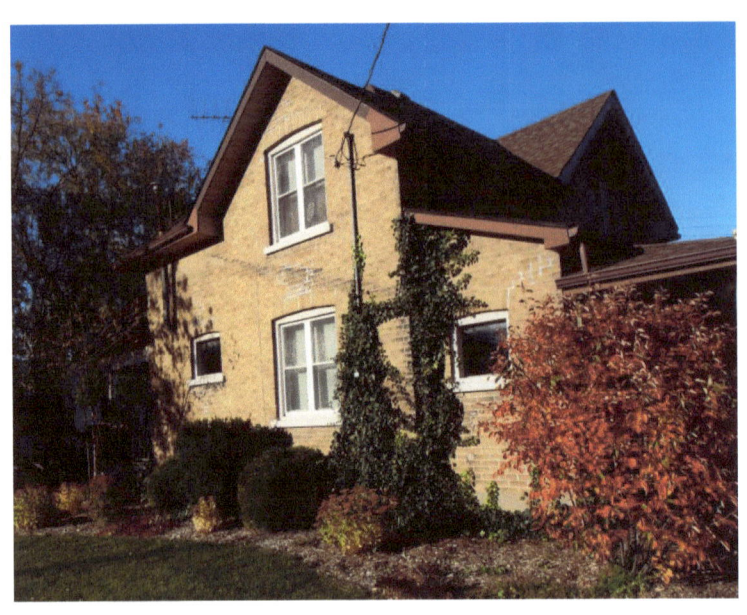

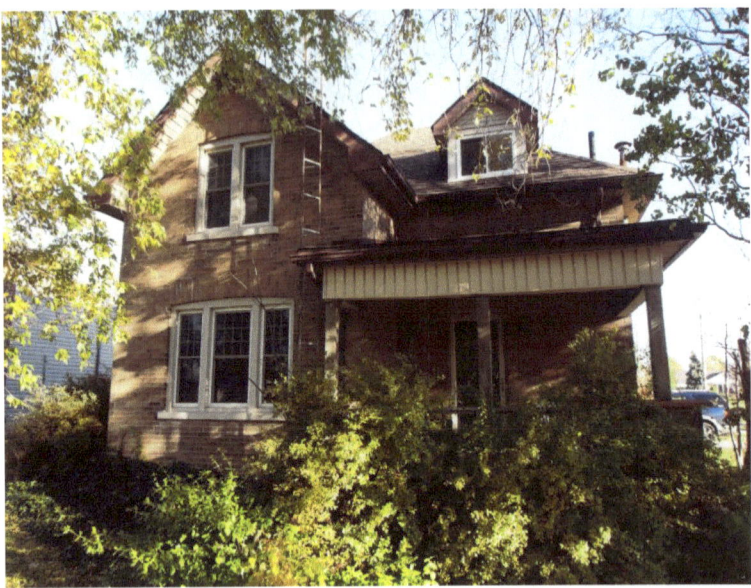

One-and-a-half storey Gothic Revival, dormer in attic

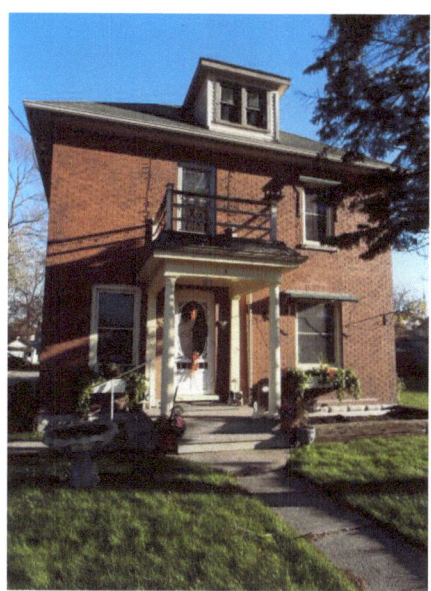

6 King Street East

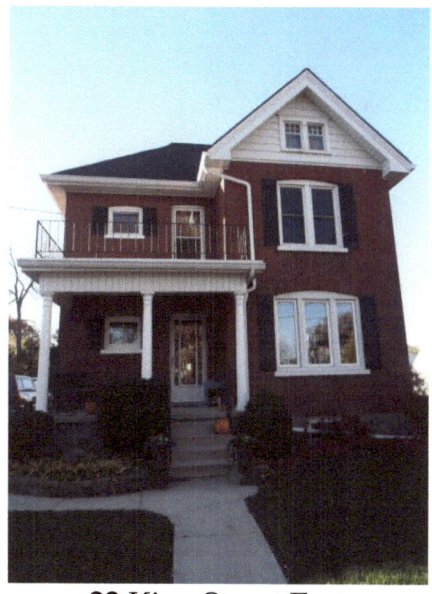

22 King Street East

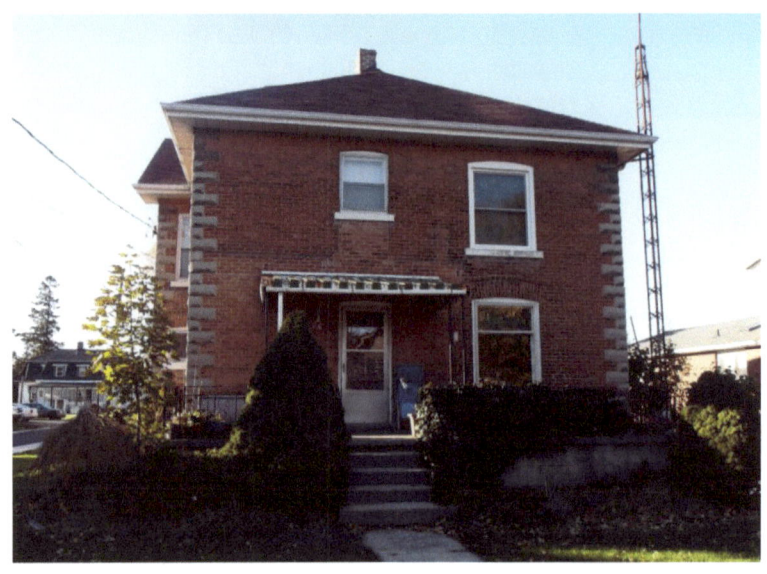

Italianate style with two-and-a-half storey tower-like bay

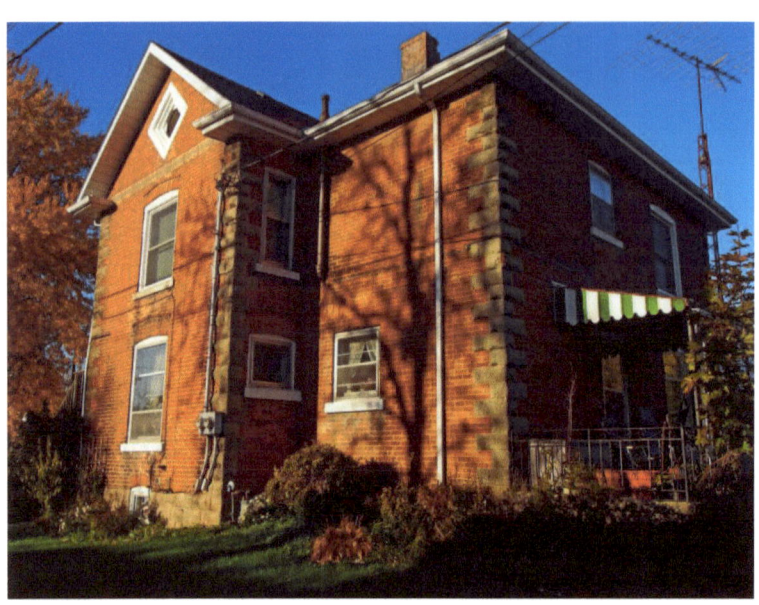

Corner quoins, cornice return on gable

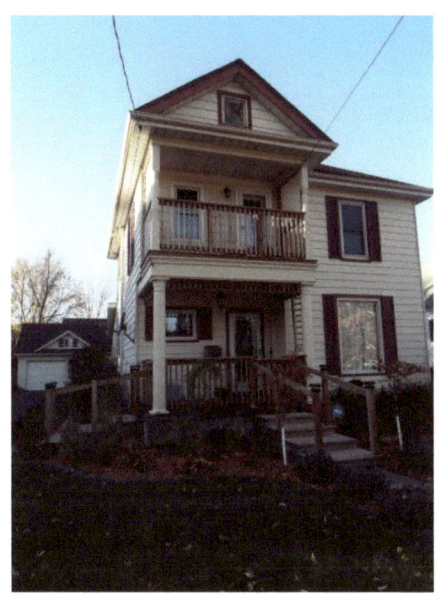

Italianate style with gable in attic

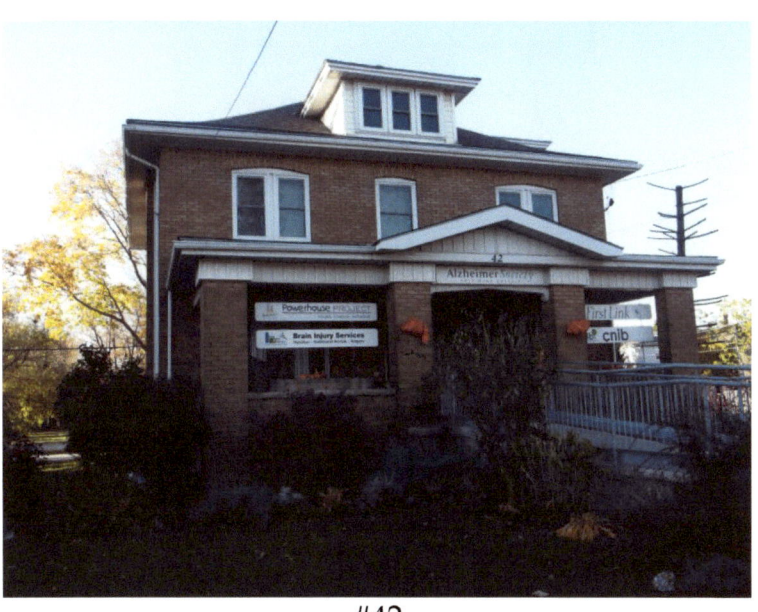

#42

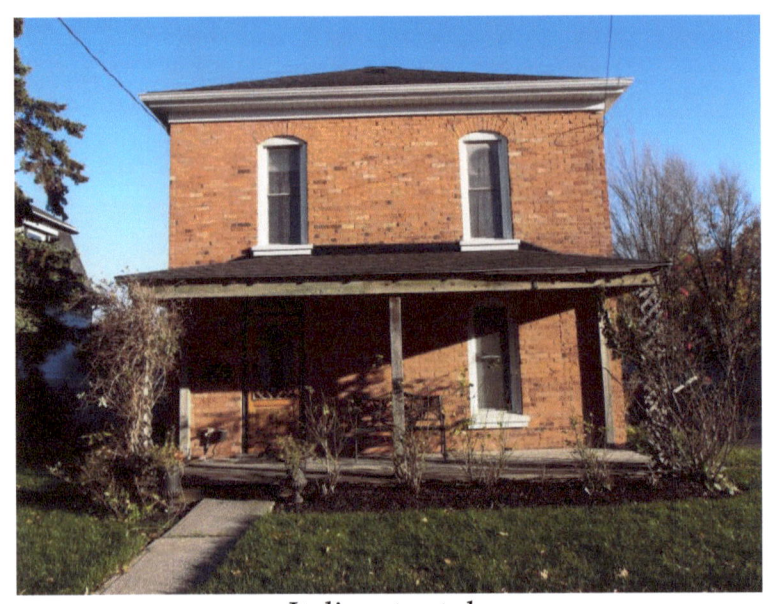

Italianate style

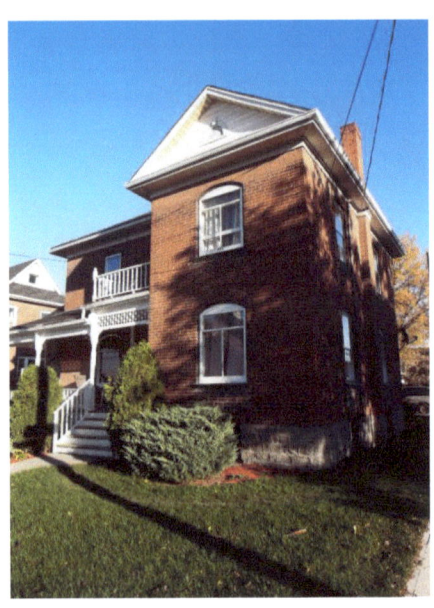

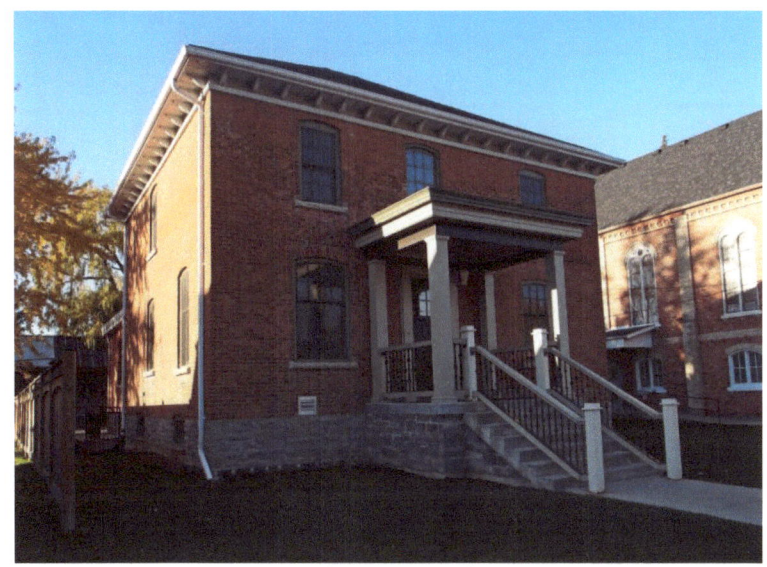

Italianate style

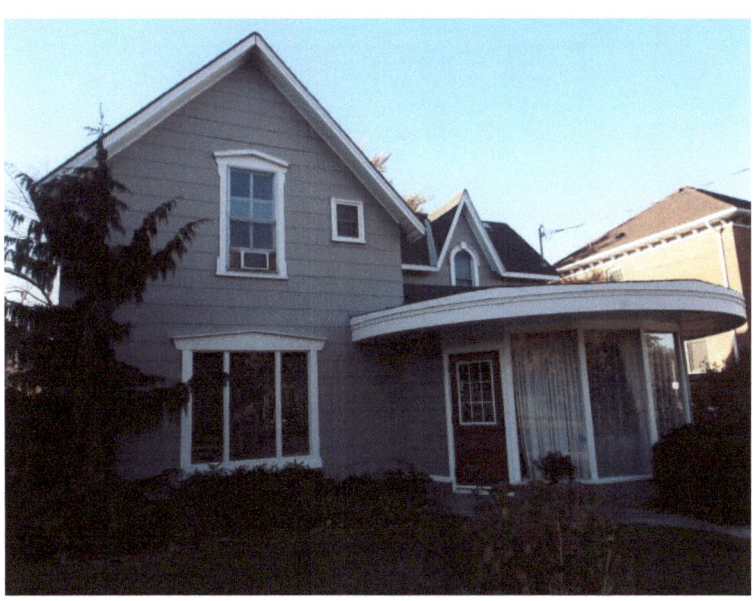

50 Park Place - Gothic Revival style

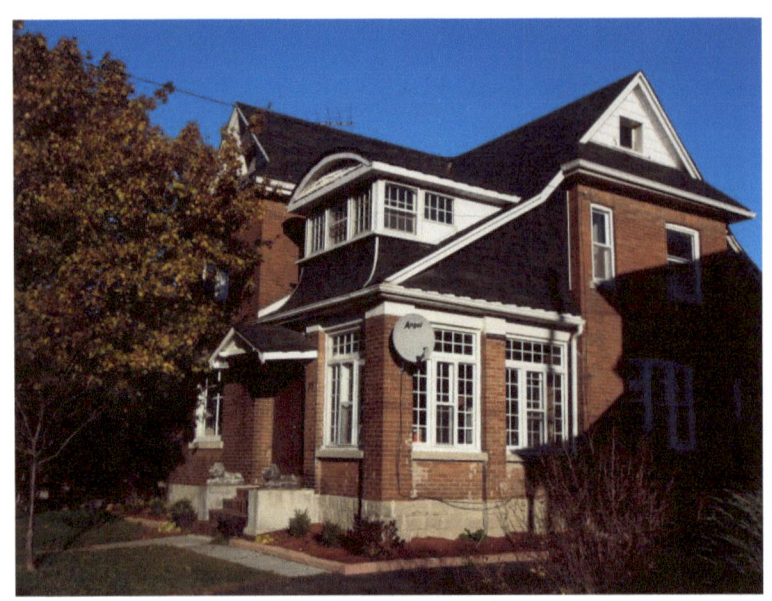

Queen Anne style

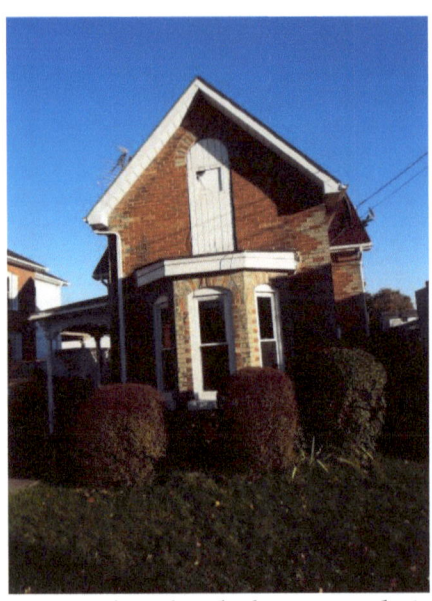

Gothic Revival style, dichromatic brickwork

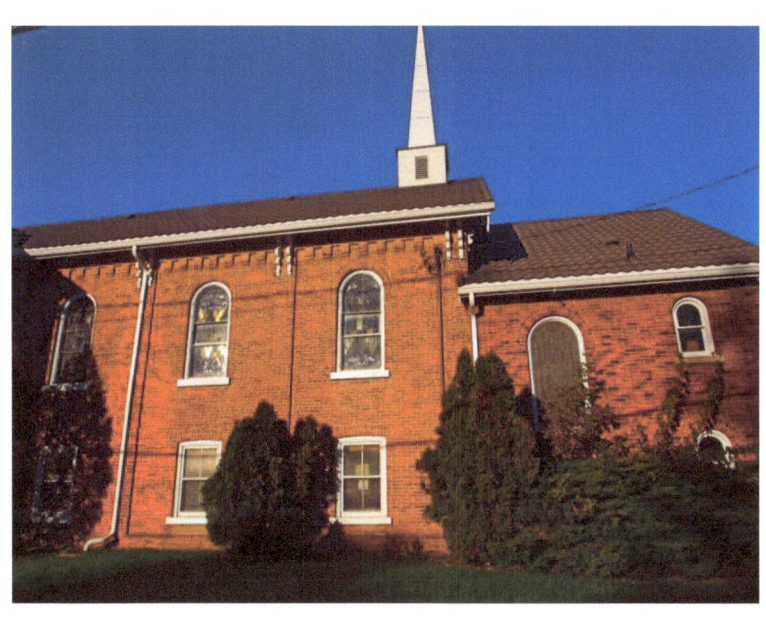

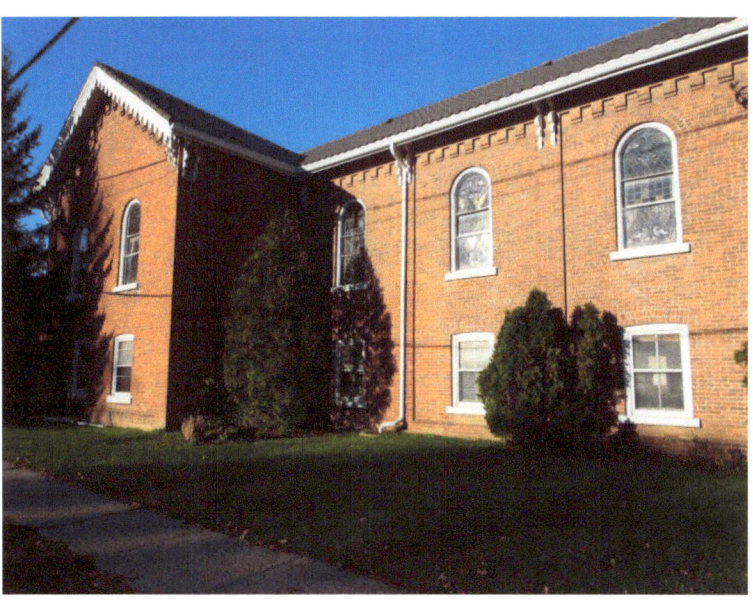

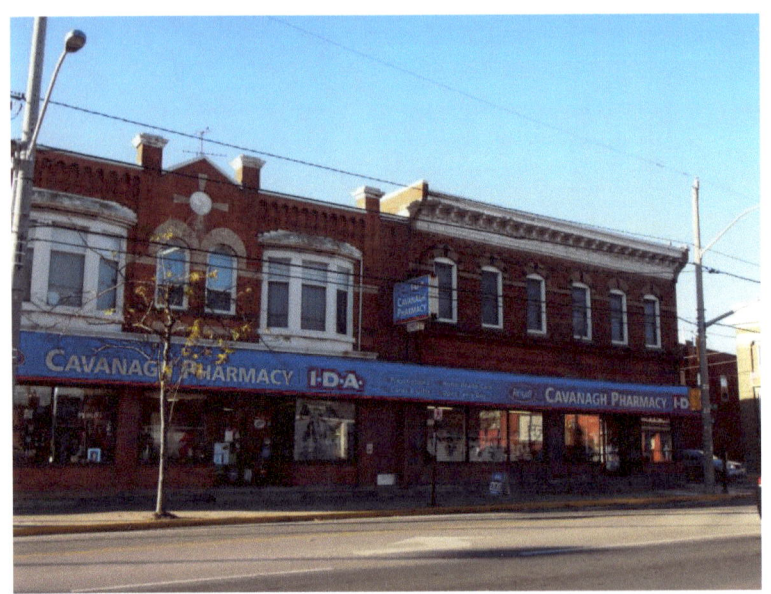

Decorative brickwork

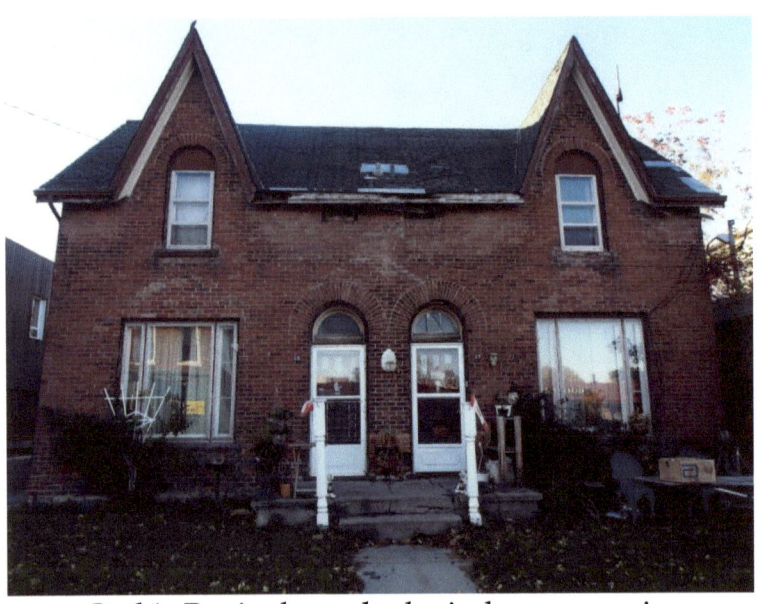

Gothic Revival – arched window voussoirs
#15 and #17 - duplex

Architectural Terms

Belvedere: (from the Italian "beautiful view") an architectural feature on a roof, in a garden or on a terrace that gives a beautiful view.	
Brackets: a decorative or weight-bearing structural element which forms a right angle with one side against a wall and the other under a projecting surface such as an eave or roof.	
Buttress: a masonry structure built against or projecting from a wall which serves to support or reinforce the wall. In Canadian architecture, they are sometimes used for decoration.	
Cornice: originally the wooden overhang of the roof. With the use of stone, brick, iron and steel, the cornice is any projecting shelf at the top of a ceiling or roof. They can be very decorative.	
Cornice Return: decorative element on the end of a gable.	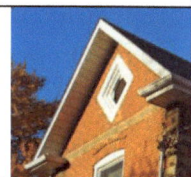
Dentil Moulding: an even series of rectangles used as ornamental decoration in cornices.	
Dichromatic brickwork: the use of two colours of brick, tile or slate to decorate a façade. Example: Alma Street South	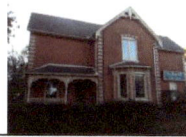

Dormer: (French for "sleep") a gable end window that pierces through the plane of a sloping roof surface to create usable space in the top floor or attic of a building by adding headroom. Example: The Old Lawson House	
Gable: the triangular portion of a wall between the edges of a sloping roof. Example:	
Keystones and Voussoirs: a voussoir is a wedge-shaped element used in building an arch. A keystone is the central stone that locks all the stones into position, allowing the arch to bear weight. A keystone is often enlarged and embellished.	
Quoin: masonry blocks at the corner of a wall, often a decorative feature, usually larger or of a different colour than the rest of the wall.	
Vergeboards: also called bargeboards – hang from the projecting end of a roof and are often elaborately carved and ornamented. Example	

Hagersville's Building Styles

Gothic Revival, 1830-1890 – These decorative buildings have sharply-pitched gables with highly detailed vergeboards, pointed-arch window openings, and dichromatic brickwork. It is a common style in Ontario.	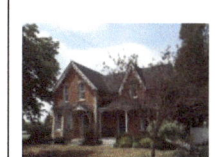
Italianate, 1850-1900 – It has wide-bracketed eaves, belvederes, wrap-around verandahs.	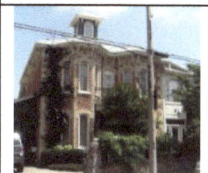
Queen Anne, 1885-1900 – This style is distinguished by an irregular outline featuring a combination of an offset tower, broad gables, projecting two-storey bays, verandahs, multi-sloped roofs, and tall, decorative chimneys. A mixture of brick and wood is common. Windows often have one large single-paned bottom sash and small panes in the upper sash.	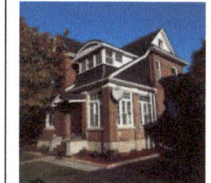
Edwardian, 1900-1930 – This style bridges the ornate and elaborate styles of the Victorian era and the simplified styles of the 20th century. Balanced facades, simple roof lines, dormer windows, large front porches, and smooth brick surfaces are its characteristics. This example is reminiscent of this style.	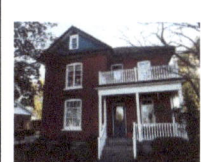

www.ingramcontent.com/pod-product-compliance
Lightning Source LLC
Chambersburg PA
CBHW041611180526
45159CB00002BC/815